Medieval
Tapestry Designs

Dolores M. Andrew

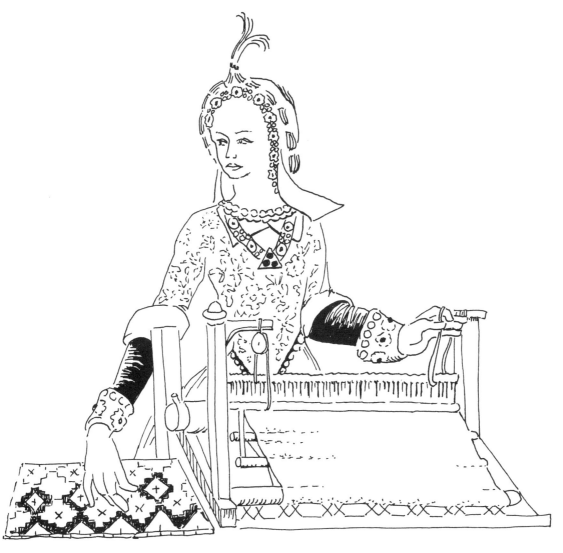

Stemmer
House
PUBLISHERS, INC.

INTRODUCTION

WHEN WE THINK OF TAPESTRIES, the image that usually comes to mind is that of immense hangings, depicting battle scenes, crowded with people in medieval costume. They are most often European in origin. However, tapestry techniques have been traced beyond recorded history and found in locations all over the world. So far, the oldest fragments have come from Egyptian tombs, dating from 1400-1300 BC, but many other areas have also produced examples, predominately Siberia, Iran and Asia Minor. Evidence found on Greek vases circa 550 BC shows the several steps in the tapestry-weaving process. We don't know where tapestry originated, but we do know its roots go back a very long time.

What is tapestry, and what is not? True tapestry is weaving done on a loom, with the fibers woven over and under each other. The design is woven into the material as it is created, so that it is part of the textile. The left-to-right fiber is called "weft"; the vertical is the "warp." By varying the relationship of the horizontal to the vertical, several different weaves are possible, and patterns are thereby created.

The most basic weaves are called tabby, twill and satin. Tabby is created as the weft weaves over and under, covering the warp, in a one-to-one relationship: over one, under one. Twill results from a variation of this: over 2 or 3, and under one. Often a diagonal pattern is created, sometimes resembling herringbone. When the spacing is done on a wider variation, the satin weave results, giving a smoother appearance. Many variations and combination of these are possible in creating a design. Other more complicated weaves use extra weft yarns inserted across the warp, resulting in raised or knotted patterns of various types. Color changes are handled by the overlapping, dovetailing or interlocking of the warp and weft.

Many textiles that go by the name "tapestry" actually are not. Tapestry embroideries or embroidered tapestries have existed under many guises and many names over the centuries. Some of the pieces so called are done in crewel, some are done in needlepoint and some are in reality stumpwork. Often they are called tapestries only because of their monumental size. Sometimes they are just misnamed. The most famous of these is the Bayeux Tapestry, which is embroidery on linen, dating from the eleventh century.

Tapestry embroidery has enjoyed brief periods of popularity over the centuries. It seem to appear, with no beginnings, and fades just as quickly when tapestry ceases to be popular.

Present-day magazines often carry articles about "tapestries," done for a church or for some commemorative occasion, which really are canvas embroidery, commonly called needlepoint. Well-known examples of these are the Voortecker in South Africa and the Overlord in Great Britain. Both are embroidery on canvas, a squared fabric. Both tell epic tales and are of mammoth proportions, but they are canvas embroideries, not tapestries.

The difference is that in a tapestry, the design is woven into the fiber; in a tapestry embroidery the design is stitched on an existing ground.

Over the centuries, the fibers used to produce tapestries have varied, but most have been made from wool, cotton, linen or silk in various combinations. Wool has always been most readily available in most cultures, and many species of animals have coats that can be used in tapestries. Besides the sheep, some of the finest wools came from Kashmir and angora goats of Tibet. The vicuna of Peru is also very good. Some countries favored camel hair. Of course, the quality of the fiber varies greatly, depending on the climate of the area and the age of the animal.

Silk was added to tapestries in Europe when silkworm culture was introduced to the West at the time of Marco Polo. Until then, tapestries were all of wool, flax or cotton. Metal threads, though used sparingly, were sometimes inserted for added lustre or accents on costumes.

Looms generally followed a basic principle: Warp threads were stretched between two poles, which were fastened to a support. The weft threads were passed in and out or over and under to create the design, using the hand or sometimes a foot treadle. Sometimes the looms were fixed vertically and called "haute-lice," and sometimes they were worked horizontally ("basse-lice"). Over the centuries, the looms grew larger and more technically refined, as more challenging sizes and subjects were desired by patrons. As if this were not challenging enough, the weaver had to create the design working from the rear, sideways.

Just as in art and embroidery, tapestry *themes* have developed from simple to complex, Biblical to secular. Ancient fragments show animal shapes often interspersed with abstract or geometric designs. They were stylized, not anatomical, and often used in a repeat pattern. During the "Dark Ages," the early Christian era, simple shapes like plants, birds, and animals were handled in stylized and decorative manners. Human shapes were also stylized and simplistic, not "drawn well. While they lacked many anatomical details, they showed surprising skill and sensitivity in many other areas. The fact that weavers had little drawing knowledge didn't stop them. They created, making important figures larger than those important, overlapped for perspective, and didn't worry about proportions.

With the Middle Ages, tapestry blossomed into maturity. Biblical stories, both Old and New Testament were very popular. Abraham, Esther, Jacob, Daniel, Christ, the Virgin Mary and most saints were chronicled. Most often they were shown wearing contemporary costume. Figures were still stilted; perspective was "imaginary," with no allowance for the relative size of the figure to buildings. All faces wore stern, sober expressions. Few, if any, children were ever depicted. As the Middle Ages progressed toward the Renaissance, more secular themes appeared, scenes of daily life, such as falconry, wine making, ladies with embroidery. Allegory, mythology and heroic poetry added other subject matter. Just as we in twentieth-century America venerate the great men of our past, people of medieval times commemorated kings, heroes and conquerors of their past in their tapestries.

Decorative bands were often used, containing explanatory phrases along the edges. Sometimes the band was floral, sometimes a legend explained the story, described the events, or named the figures portrayed. Due to the limits of the weaving technique, and the antique forms of the language, these legends are often difficult to read.

Medieval tapestries were crowded. Figures, buildings, plants, horses, and many other animals vied for space, frequently overlapping. Since the patron who commissioned the work was usually an important citizen, a local noble or religious official, his likeness was frequently included somewhere in the composition. Sometimes there does not seem to be space to cram in one more figure!

Animals of all kinds were included, large and small, usually domestic, such as dogs, cats, horses and often monkeys. A lot of winged creatures, "wilde beasties" real and imaginary, crept in too. Of all the bestiary, none was more popular than the unicorn. One famous Unicorn appears in a series of tapestries at the Cloisters in New York City. Another is in the Musée du Cluny in Paris. There are many others.

Many books have been written about the unicorn theme itself, some studying the style and development in art and others attributing it with symbolic function in art and mythology. The Cluny tapestries use the unicorn theme to illustrate the senses, while the Cloisters tapestries are thought to be an allegory comparing the unicorn's capture and death to that of Christ. The unicorn is seen as a gentle but regal animal, hunted in the forest, but never captured except by a maiden, and eventually killed.

The Cloisters series, manufactured in the late fifteenth century, shows a high level of skill in design and execution. The forms all have solidity and a feeling of dimension and individuality and character abounds in the figures depicted. The anatomy is life-like and accurate, with detail in both pattern and drapery of the costumes. The trees and plants are recognizable. The Cluny series dates from about the same period, but has a more stylized feel overall. The unicorn is a benign, smiling creature, merely supporting the figure of the lady. The flowers and trees, while recognizable, don't appear to be growing; they just exist on a fanciful "millefleur" field.

These two series represent some of the most beautiful examples of the late medieval period, and illustrate the different levels of skill apparent with the different workshops and regions across Europe. Lesser workshops tried to copy the more popular masters, but were usually unsuccessful. By the late fifteenth century, workshops began to weave a distinctive mark into the selvage to protect their work from counterfeiting. This "hallmark" became more universally used, and these distinctive markings are visible on tapestries in museums today. They are not only a design note, but have become a great help in dating and tracing tapestries to their origins.

Distinctive centers of tapestry grew all over Western Europe during the thirteen to fourteen hundreds, each with its own style and hallmark. None were more popular than those in Paris, Arras and Tournai in Belgium. The Gobelin works in Belgium and Paris, under many directors, was the most well known of all. Their designs were the most sophisticated and detailed, and were executed for kings, popes and other leaders of Europe. Most leading designers sent their designs there to be woven. The factory remained a strong influence in weaving well into the eighteenth century. Tapestries were done in other countries during this time, with examples surviving from Germany, Denmark and Scandinavia; but they lacked the shading and modeling evident in the works of those of Western Europe. Well into the eighteenth century, tapestries from Eastern Europe still featured flat, stylized figures and little modeling.

The *design* process was sometimes casual by modern standards. We know nothing of most designers of these early periods or of their training; only that some were better than others at composing, some had a stylized technique, some were stiff, some were very natural. Tapestries were created in three stages: design, cartoon and weaving. Sometimes both design and cartoon were done by the same artist, sometimes not. The cartoon was a full-sized painting of the finished design. Raphael's cartoons for the tapestries which he designed for the Vatican are some of the best known as well as the largest watercolors existing, since he did both steps.

When the cartoon was delivered to the weaver, it usually became the property of the master of the workshop, unless the owner of the tapestry purchased it as well. Owning both had two advantages: it kept the workshop owner from making duplicates or re-using parts of it, and it gave the owner something to hang on the wall, keeping the tapestry to use for special occasions. It wasn't unusual for weaving workshops to use the basic background cartoon and change the figures to suit the needs of a growing clientele. This was early mass production.

Although most color has faded or disappeared completely from early fragments, we can assume that the colors which they originally possessed would have included a lot of earth tones and/or plant dyes. By the Middle Ages, three plants were known all across Europe: madder, woad and weld, and most colors for tapestries were created from these. Madder produced reds of varying value, woad was a blue dye (which Julius Caesar learned of when he encountered Britons dyed that color), and weld produced yellow. These three were, of course, the primary colors, and when mixed, produced all the others. It was these plants that were used to create the colors of the Unicorn tapestries.

Colors that were not frequently used were most purples. Just as in painting, these colors were traditionally made from grinding up precious stones and were very expensive. Blues occur occasionally in both the Cloisters and Cluny tapestries, and in some others of the medieval period.

Where the medieval tapestries were crowded with figures, the Renaissance tapestries were cluttered with things. Styles became more sophisticated, figures more anatomically correct and natural in action. Proportions became accurate, light and shade apparent. Borders were almost always used, with flora, fauna, cupids and nymphs, surrounded by more flowers, birds, columns and statues.

Tapestry design followed the trends in painting in the seventeenth and eighteenth centuries, using lavish, ornate images and detailed three-dimensional scenes. By this time form and perspective were well-developed in both painting and tapestry; light and shade was often dramatic; anatomy was natural and correct; designs were complicated but not overcrowded. Sometimes tapestries seemed to be merely copies of paintings of the time.

A form of mass production developed during the Renaissance also. Weavers found that by eliminating the more expensive yarns, such as gold and silk, they could reproduce tapestries more cheaply. Some designs were duplicated several times for customers over a broad geographic area.

Battles and revolutions took a toll of tapestries as castles were looted or completely destroyed. While tapestries were considered movable, often the strain of frequent dismantling began to cause wear and fraying. Although tapestries were usually planned for use on walls, to cut drafts and echoes, subsequent generations often decided to use them differently, in more intimate areas, or as cushions, so that they were cut up or destroyed, or disappeared altogether.

Today tapestry is enjoying a renaissance. Modern artists are employing abstract shapes as well as realism to depict events and themes of the twentieth century in woven tapestry format. Tapestry embroidery is still being produced also, still stitched on canvas or embroidered on fabric, but not woven as a true tapestry is done. The cycle comes around, as it has so many times before.

TAPESTRY COLLECTIONS ON VIEW

UNITED STATES

The Cincinnati Museum of Art, Ohio
The Brooklyn Museum, New York City
The Walters Art Gallery, Baltimore, Maryland
The Cathedral of St. John the Divine, New York City
The Cleveland Museum of Art, Ohio
Stan Hywet Mansion, Akron, Ohio

OTHER

Hampton Court, London
Ursulines' Museum, Quebec
La Fondation Abegg, Riggisberg, Switzerland
Stanislaw Wyspianski Cooperative, Kracow, Poland

LIST OF PLATES

Dedication
To Hugh for Everything, for Always

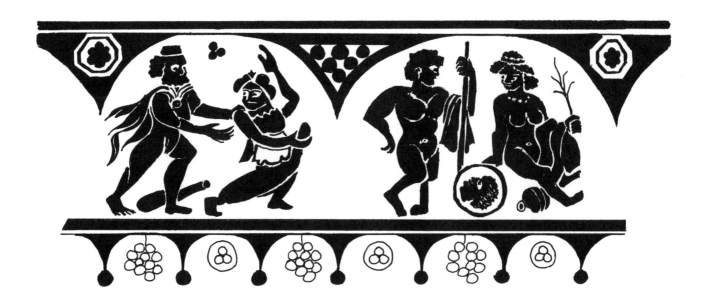

2

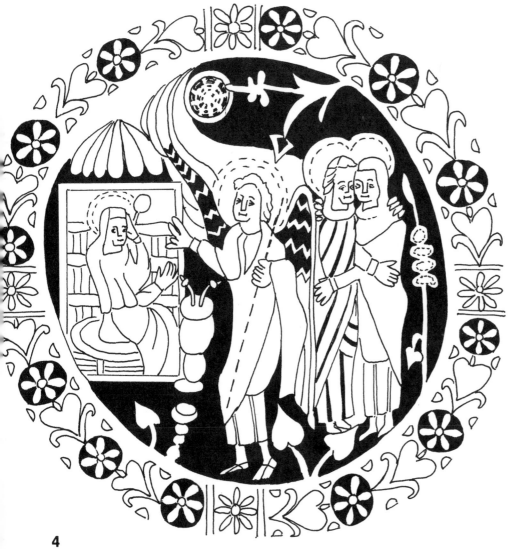

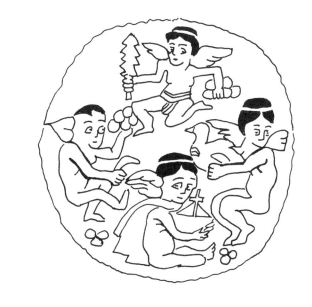

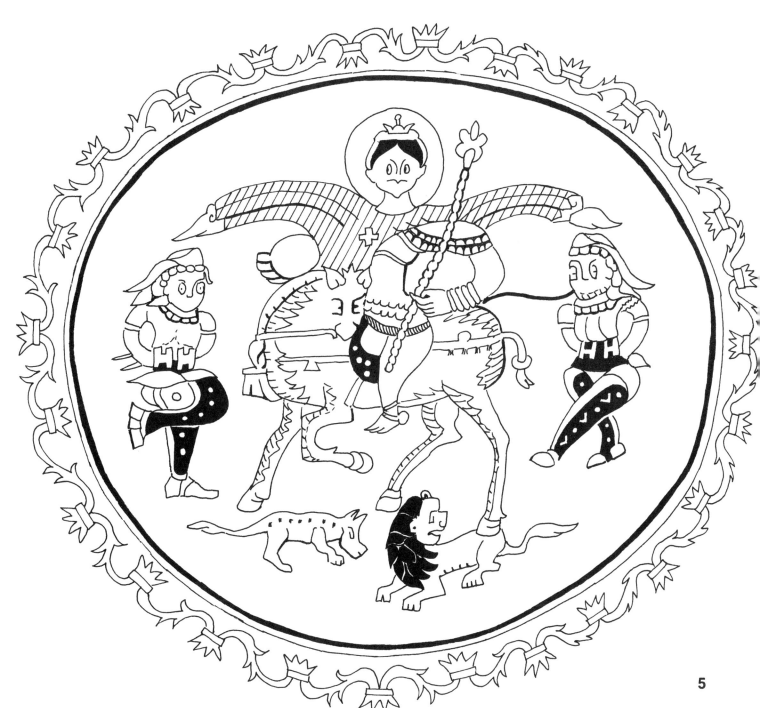

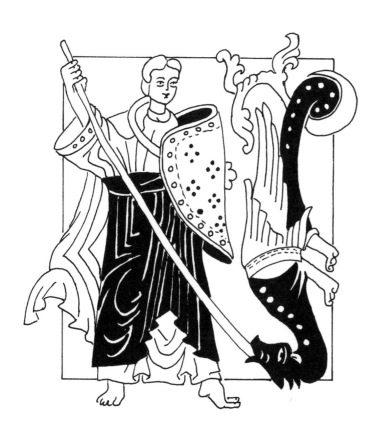

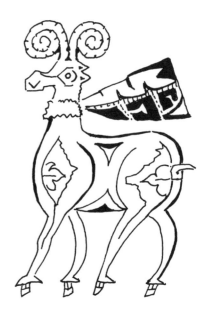

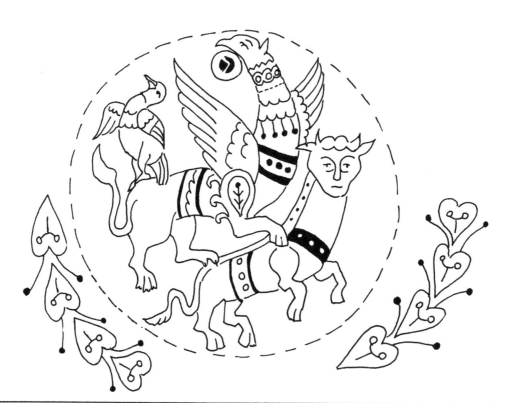

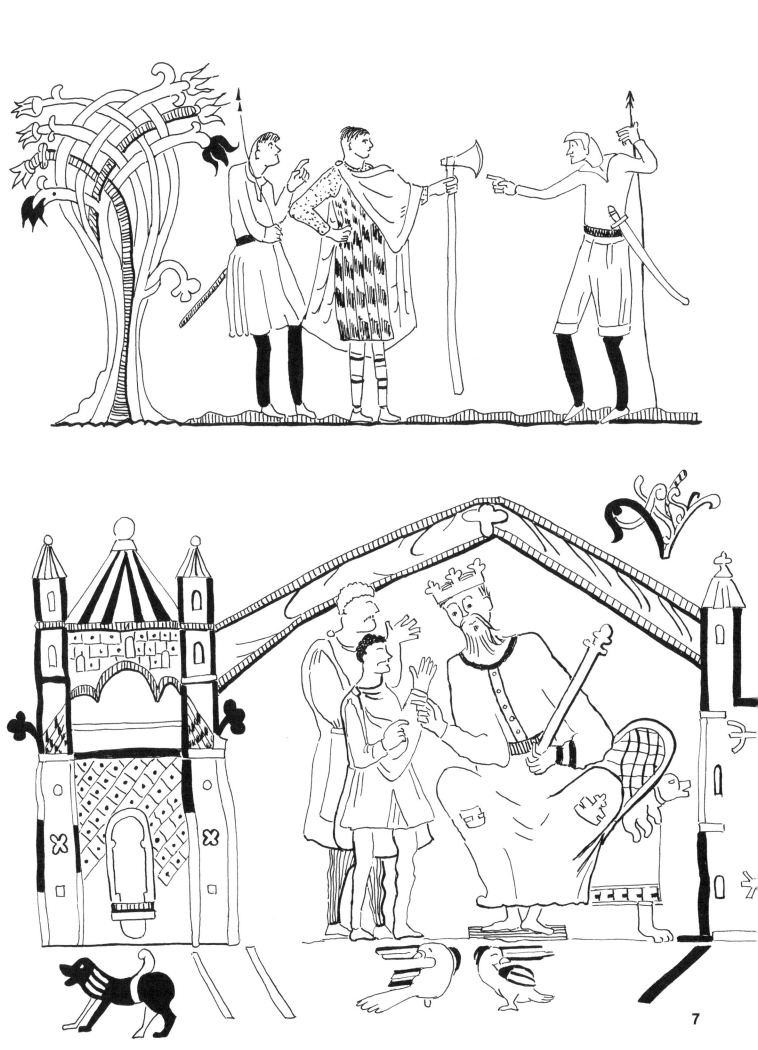

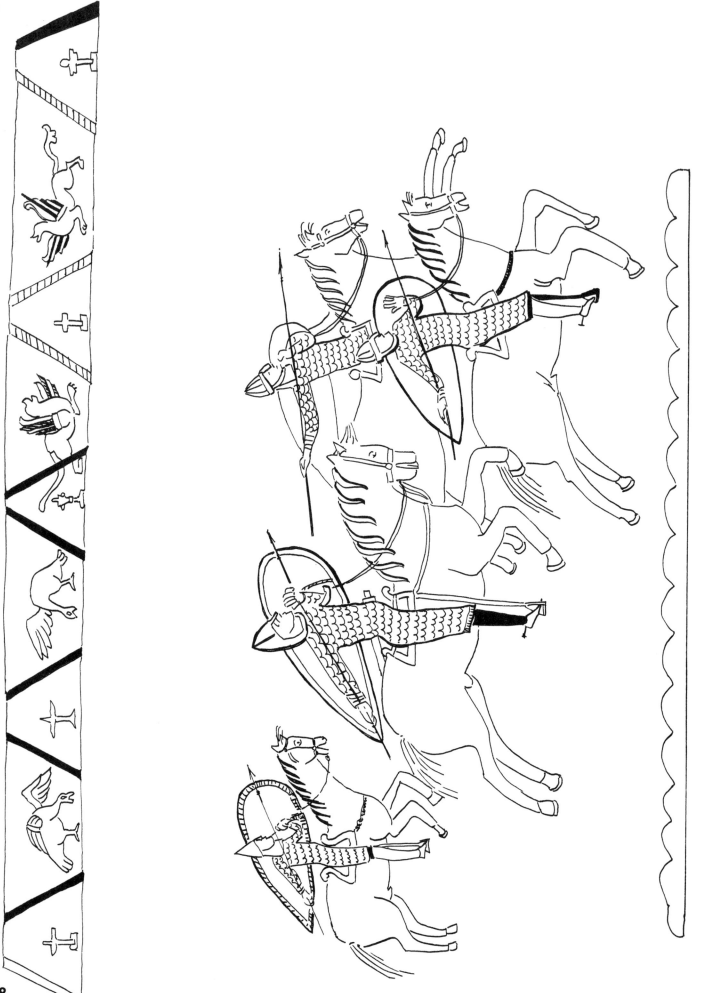

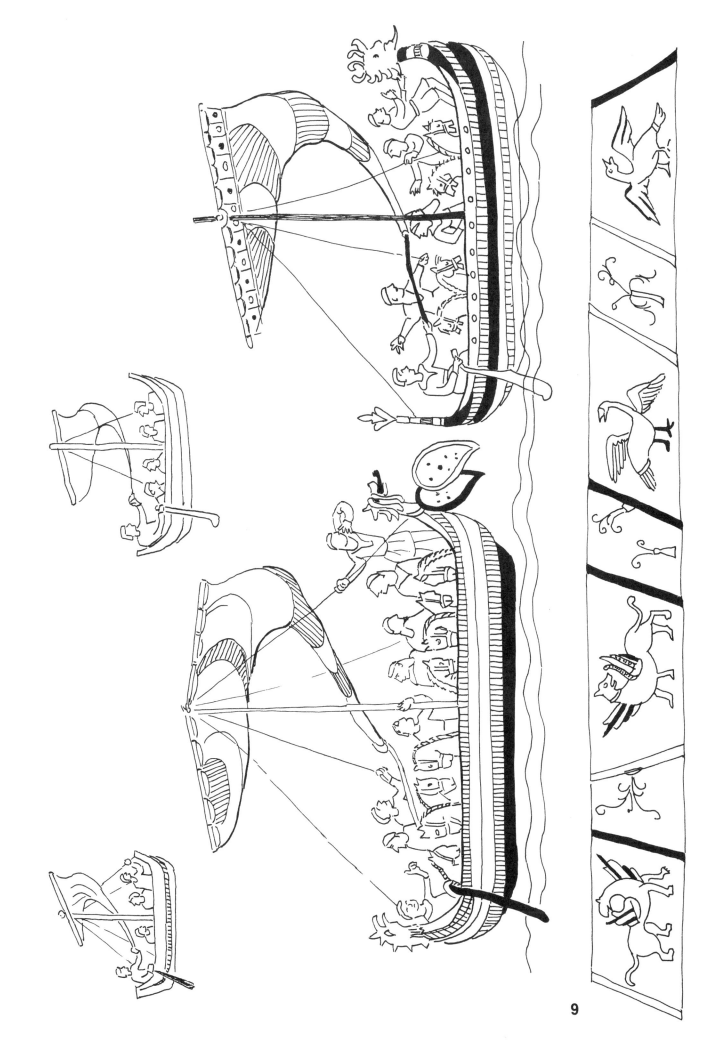

9

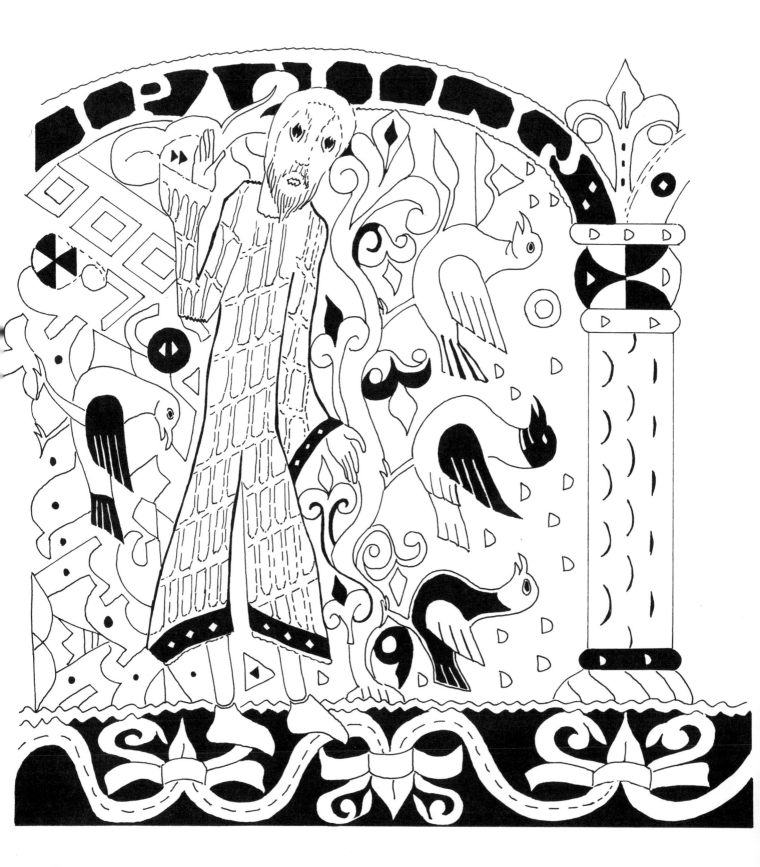

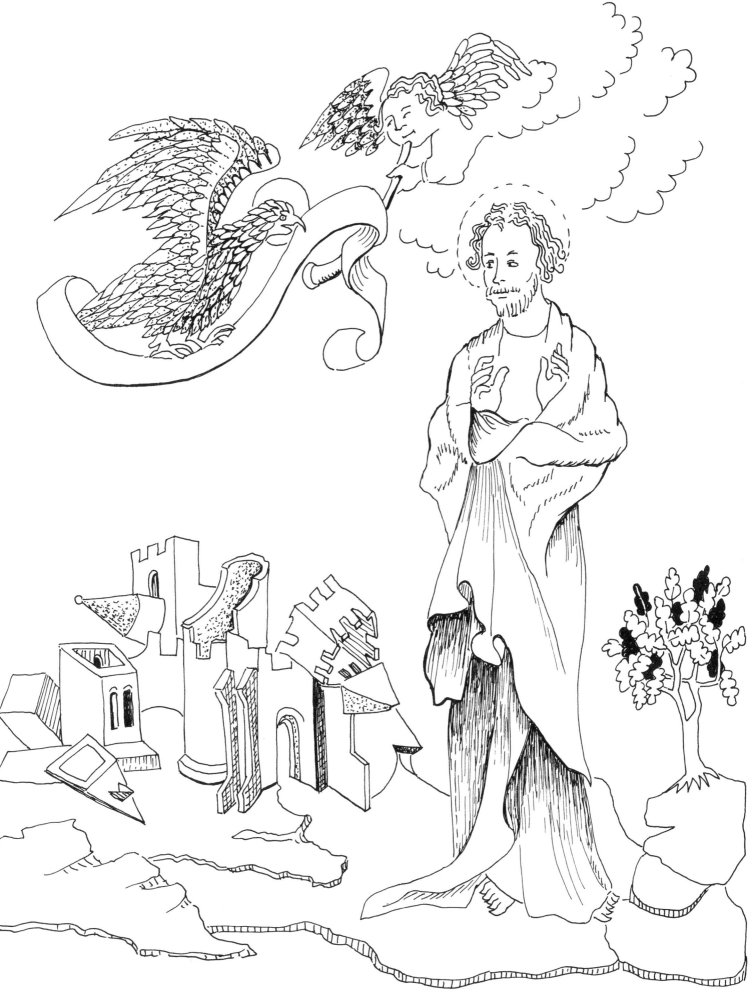

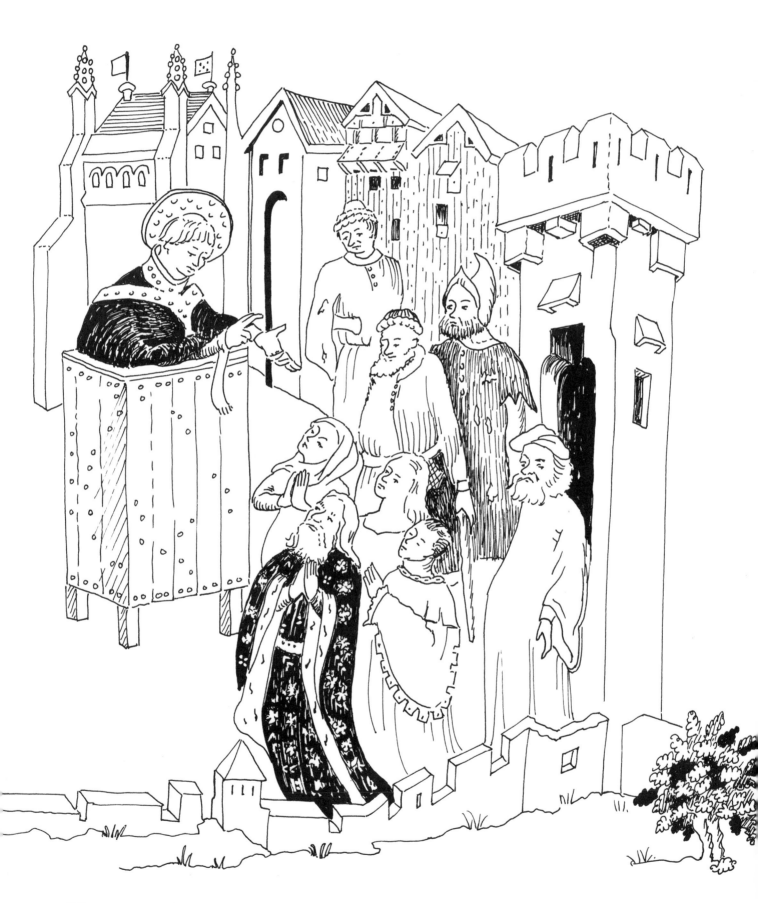

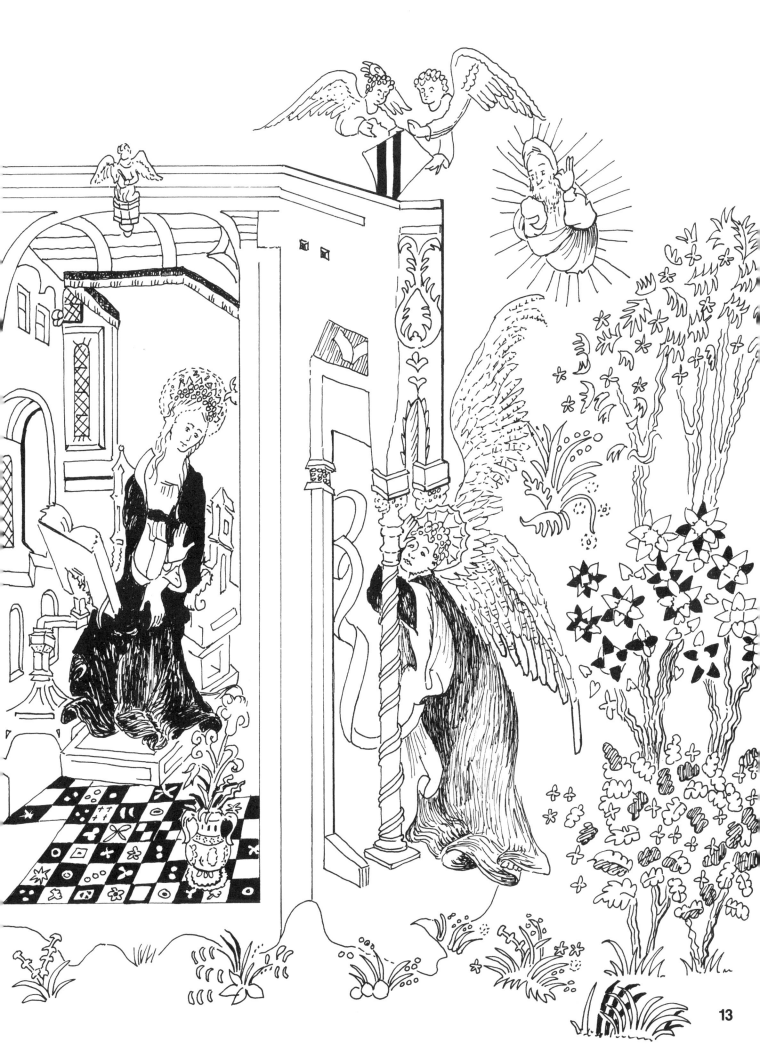

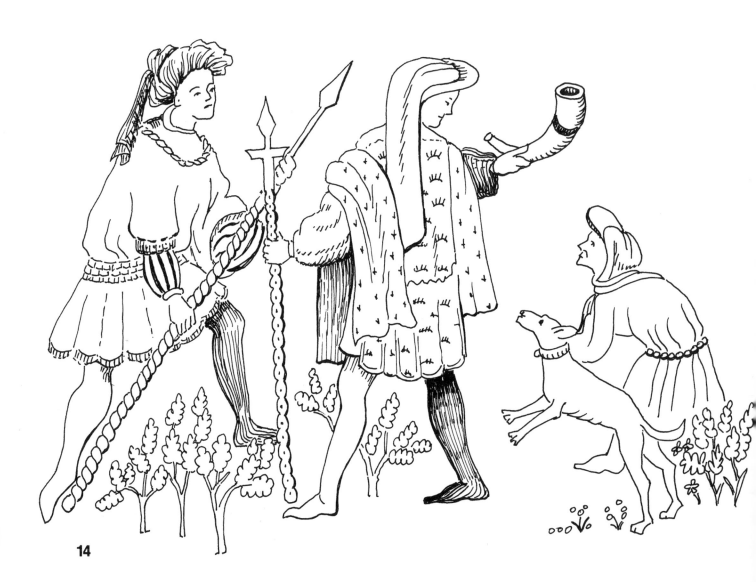

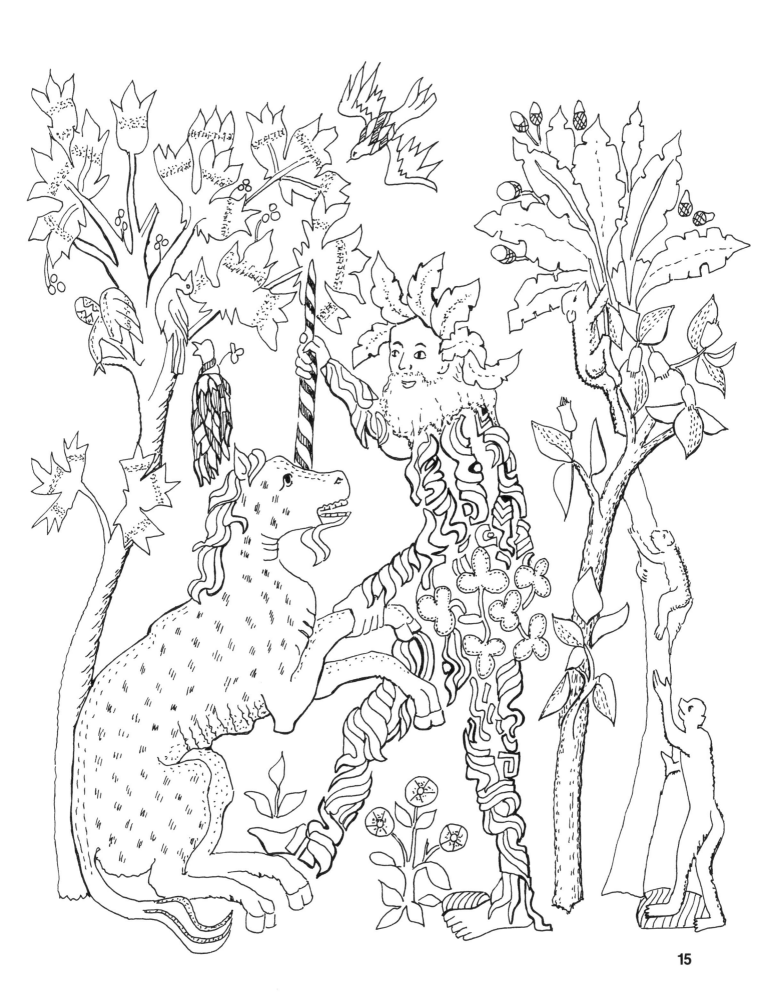

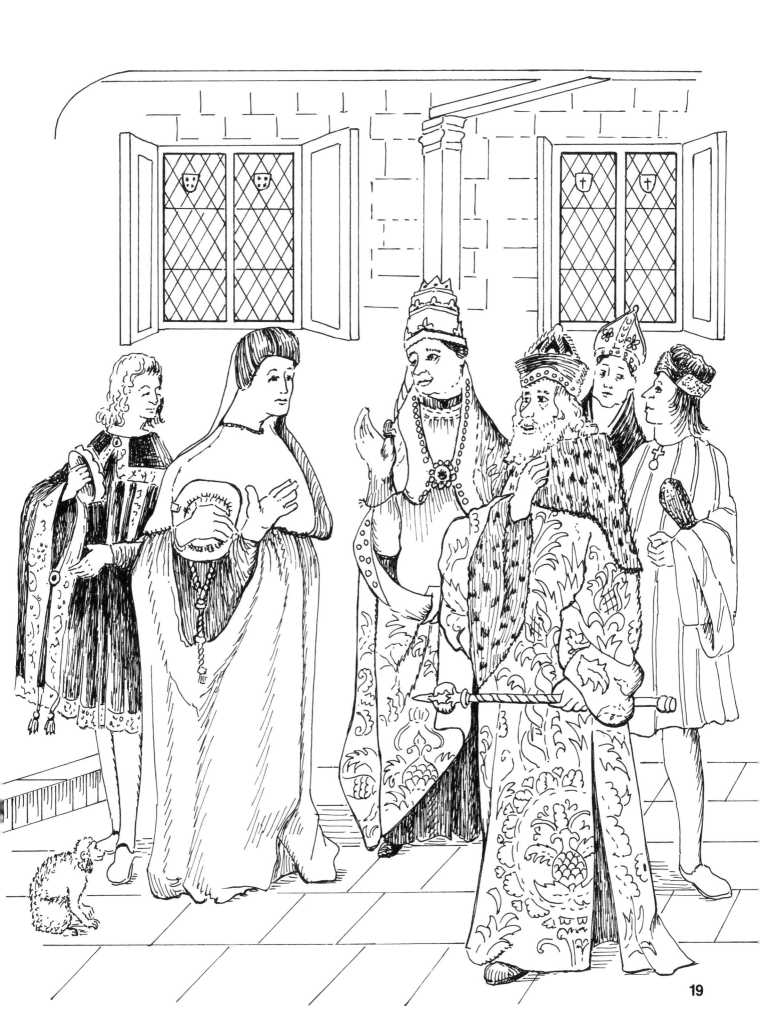

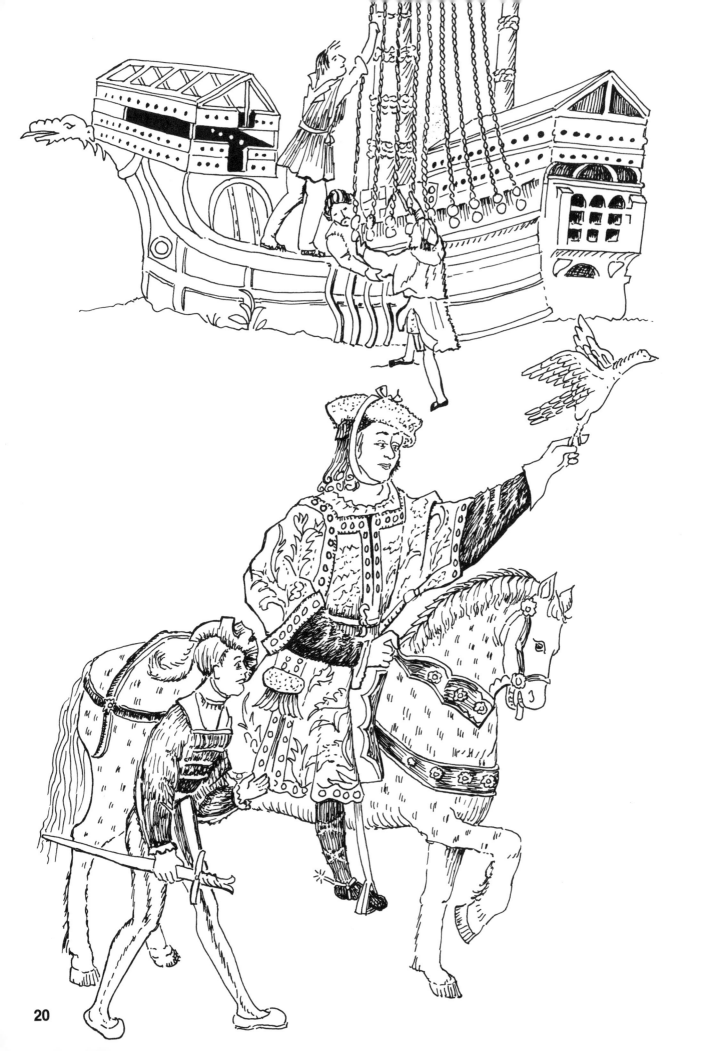

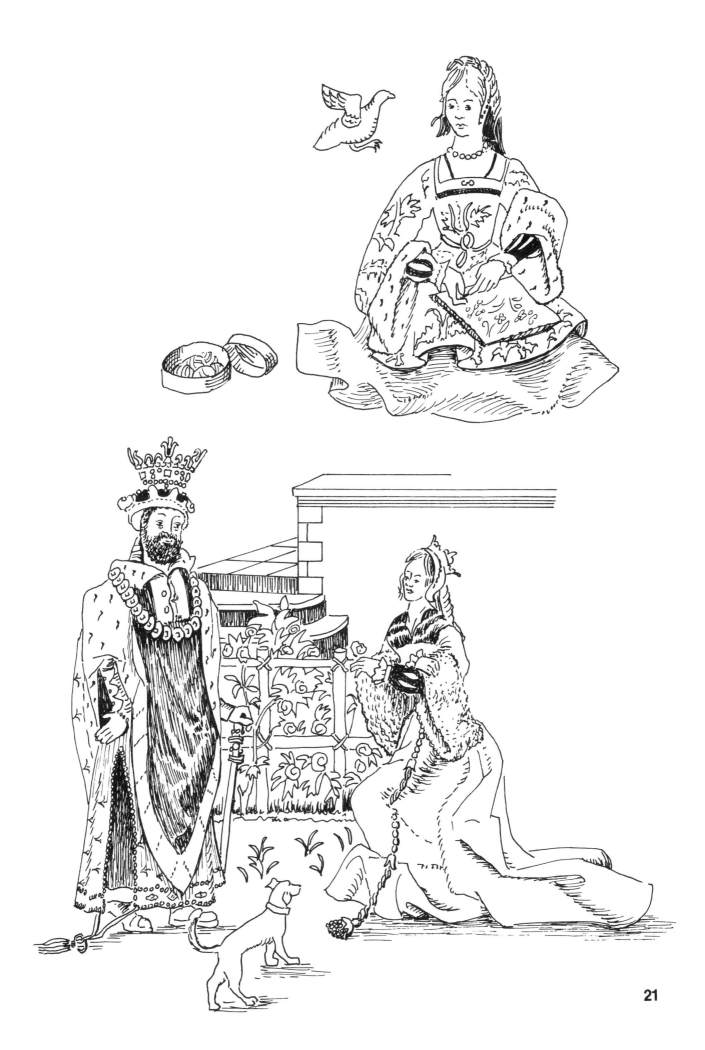

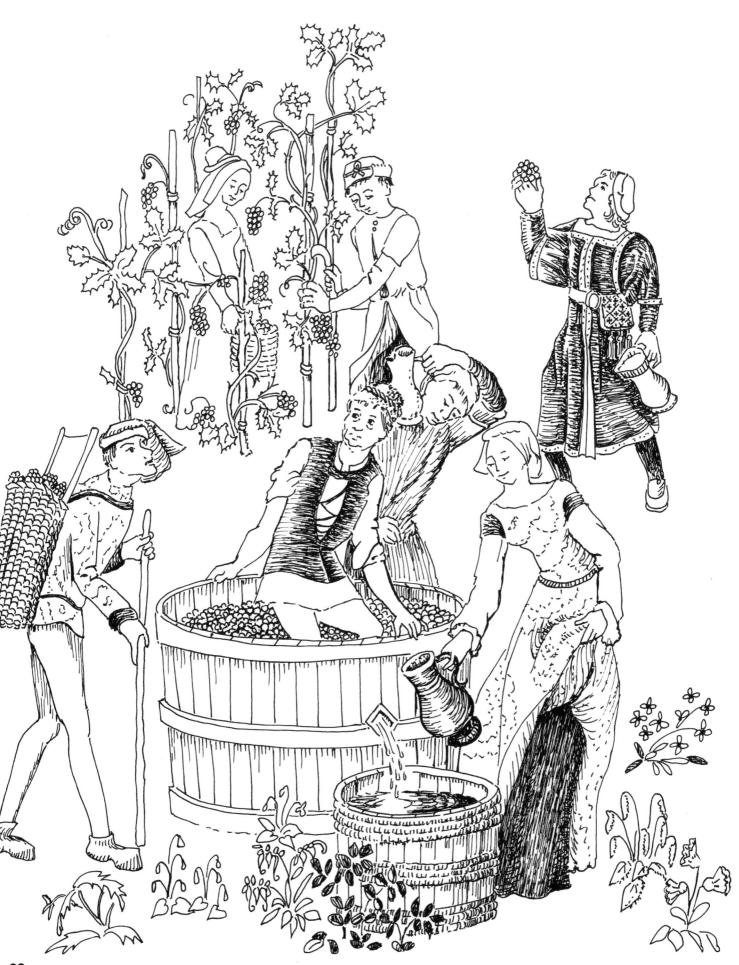

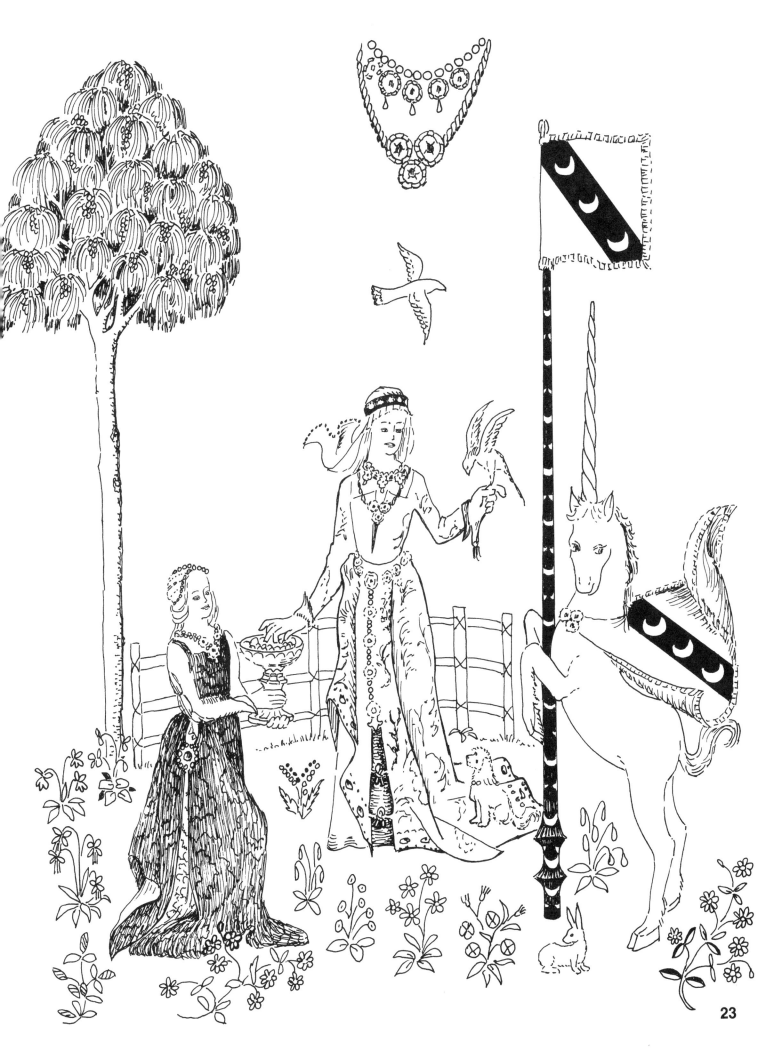

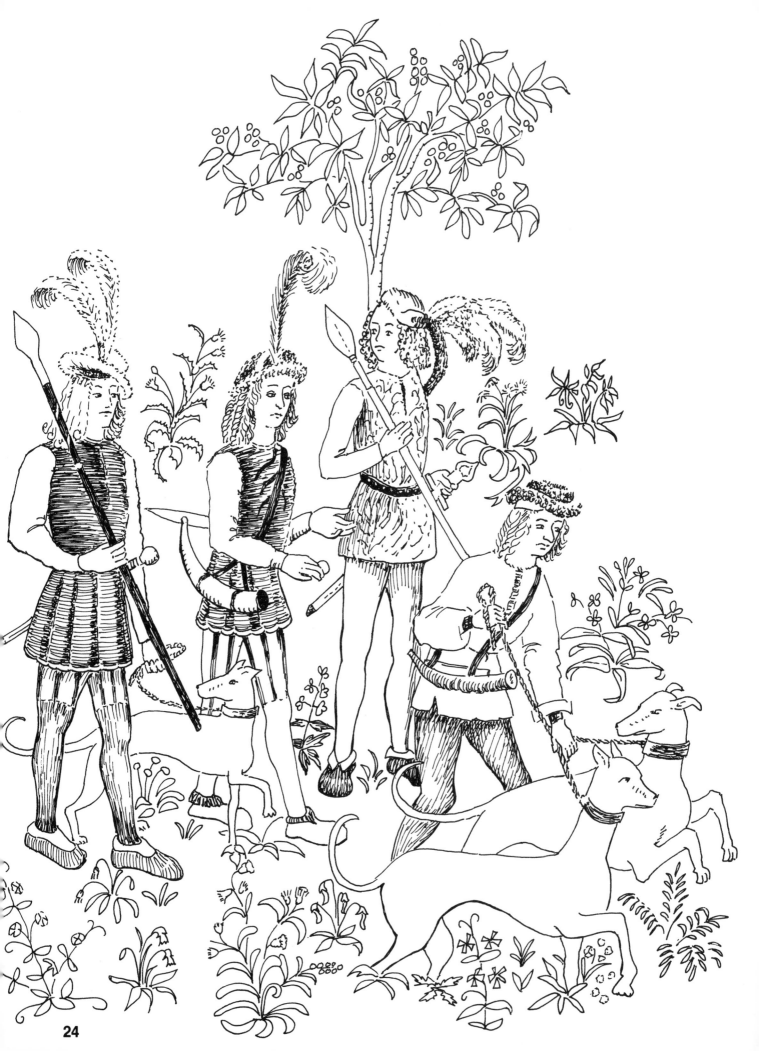

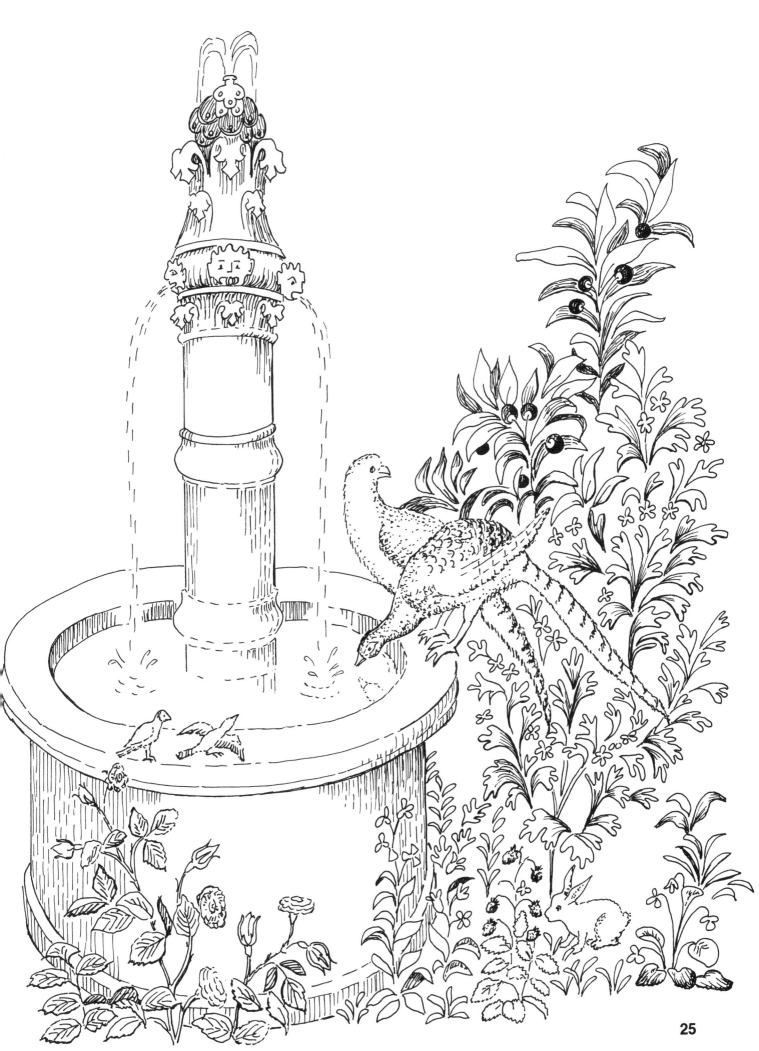

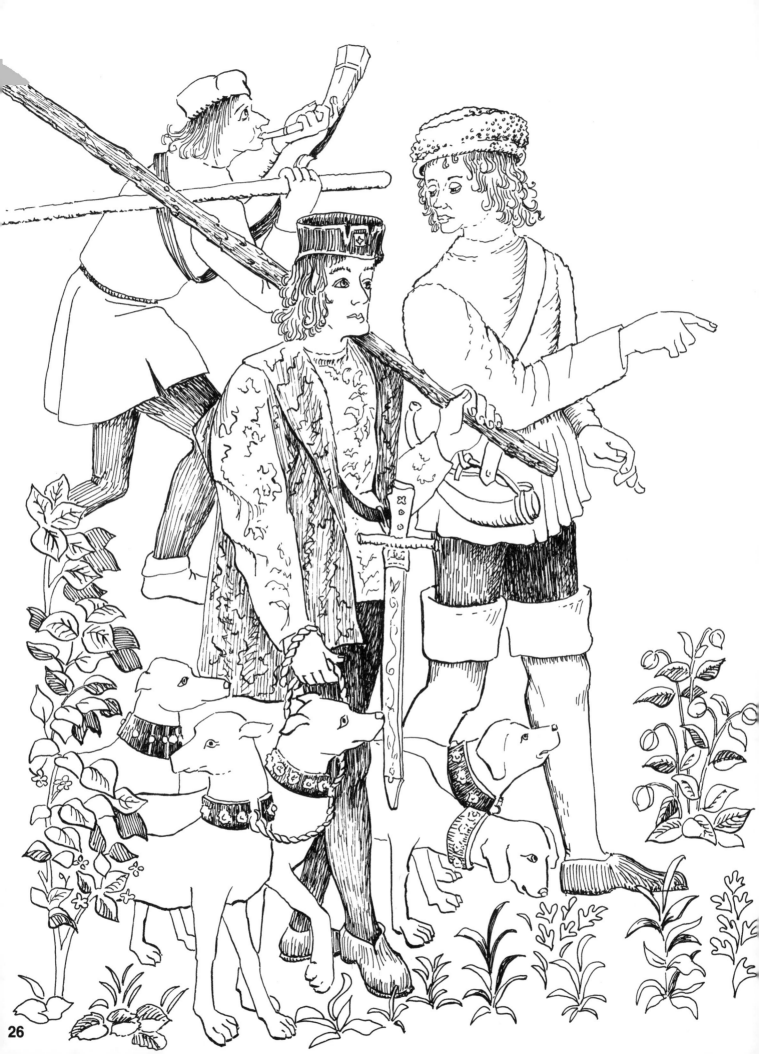

26

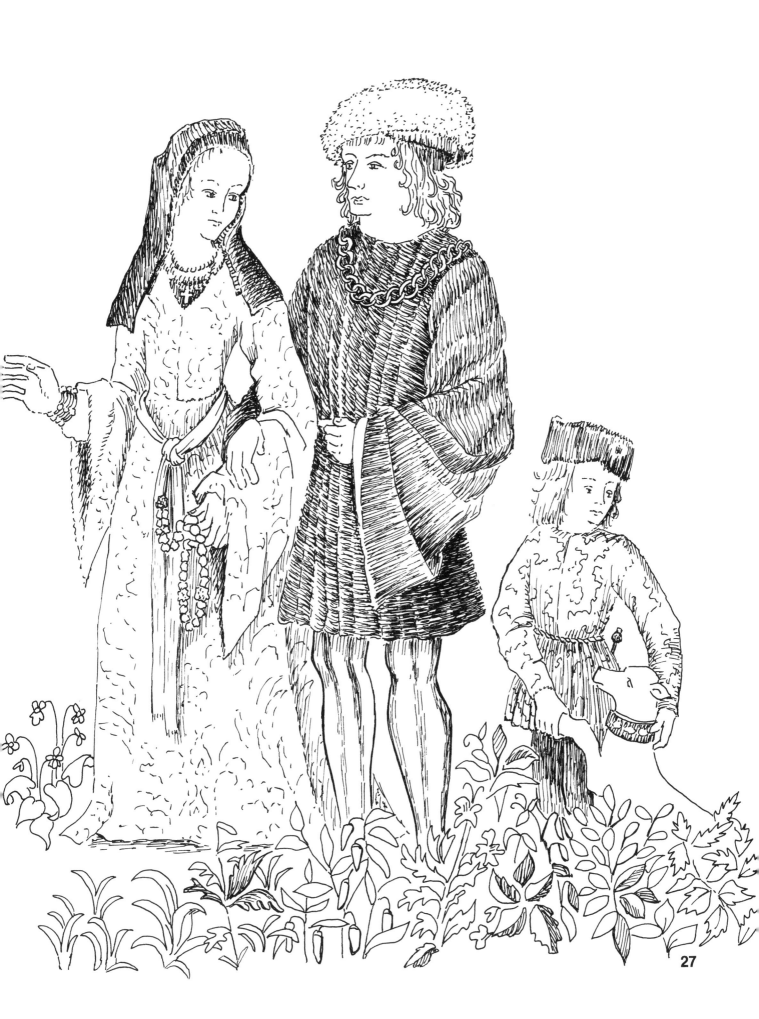

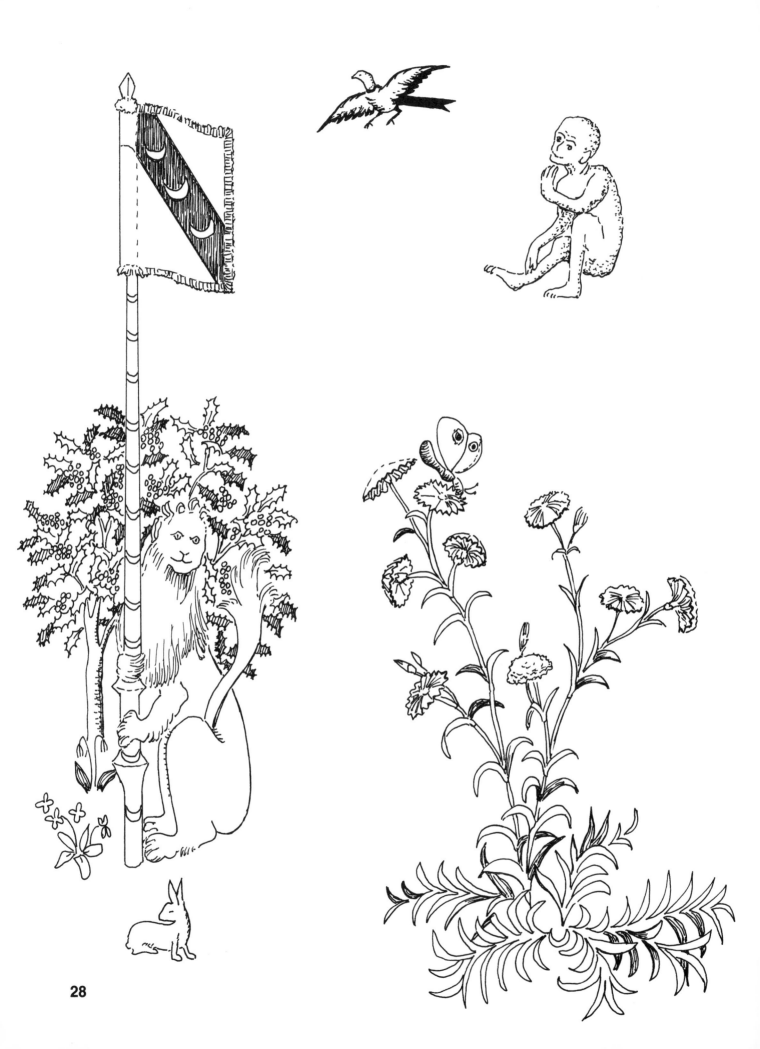

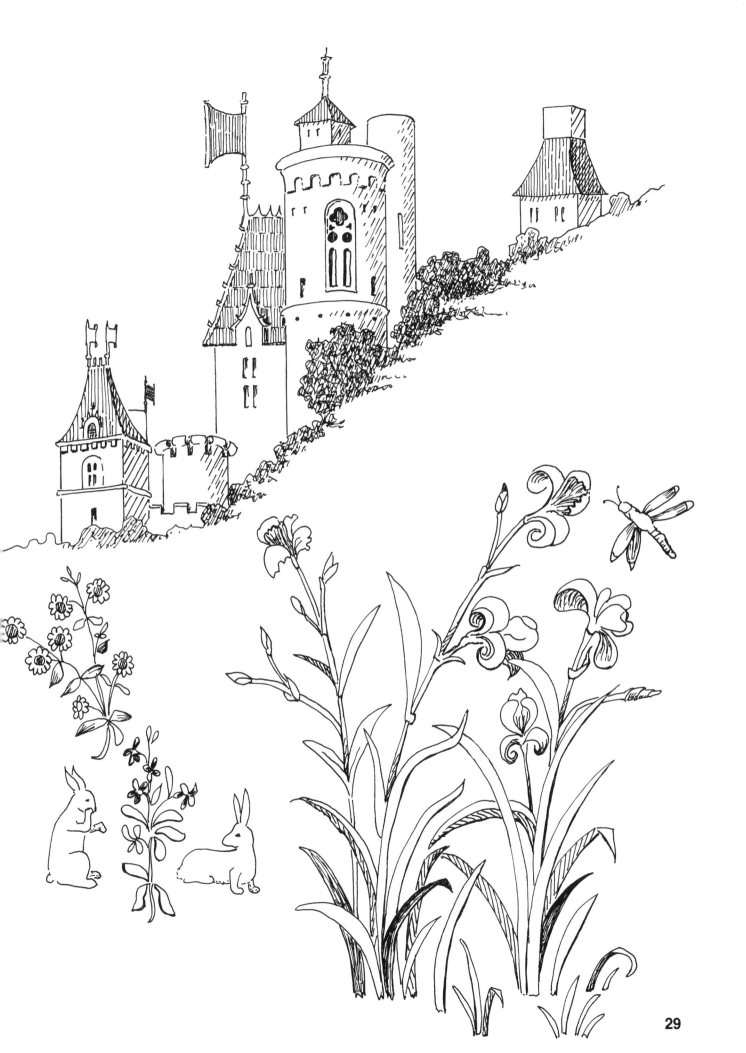

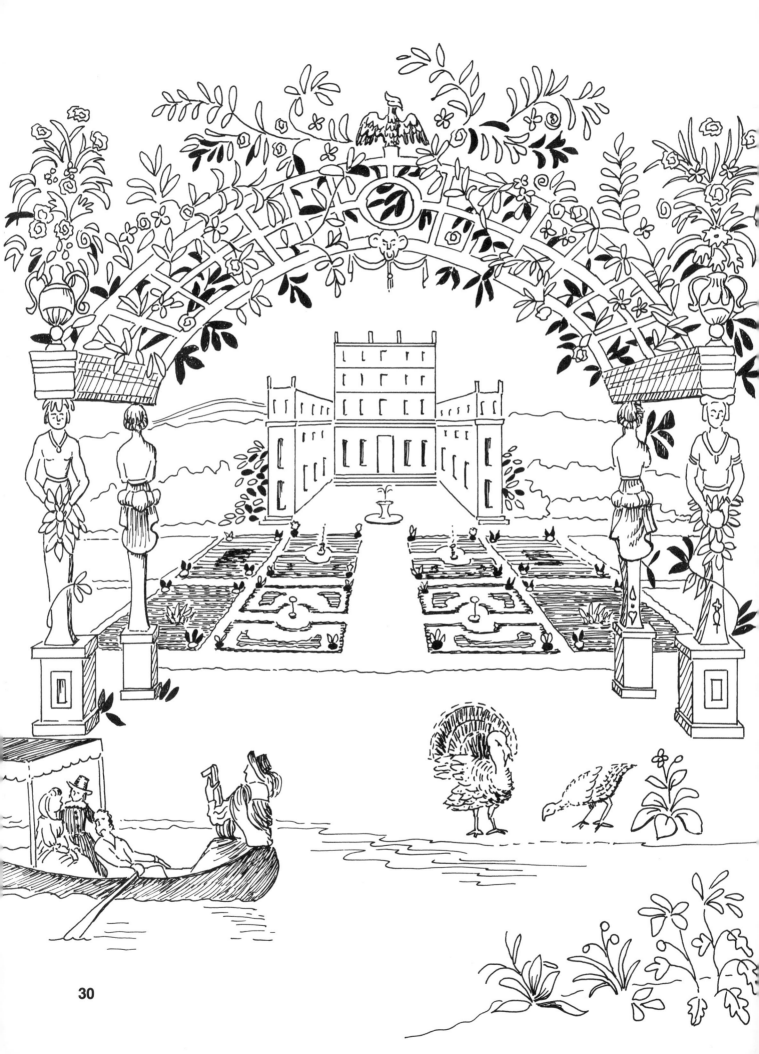

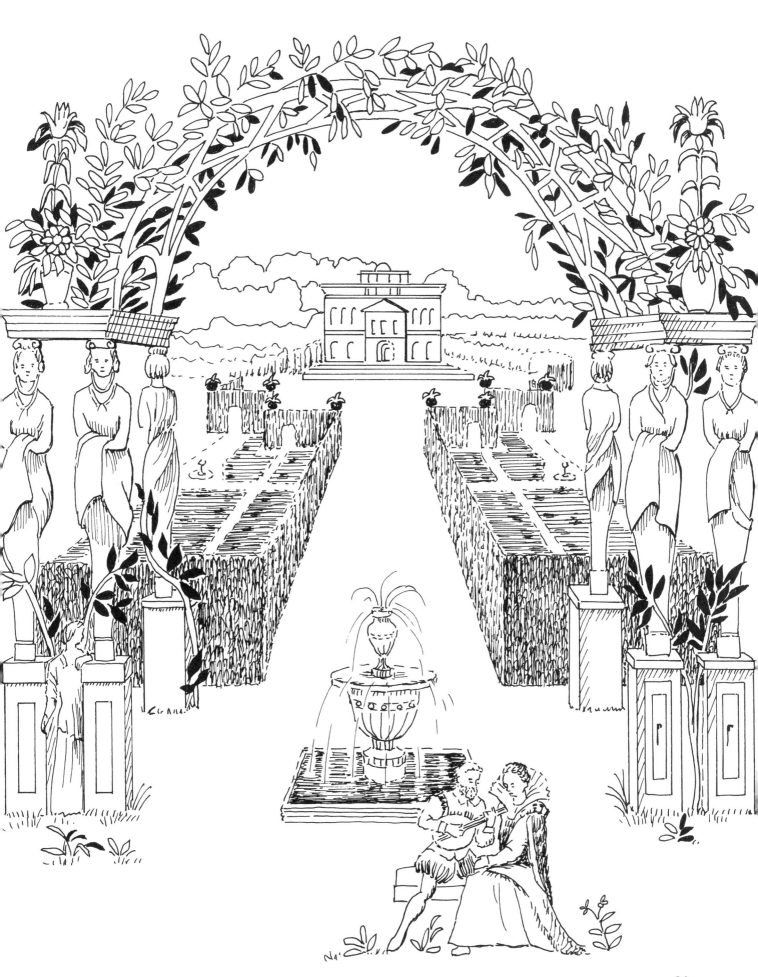

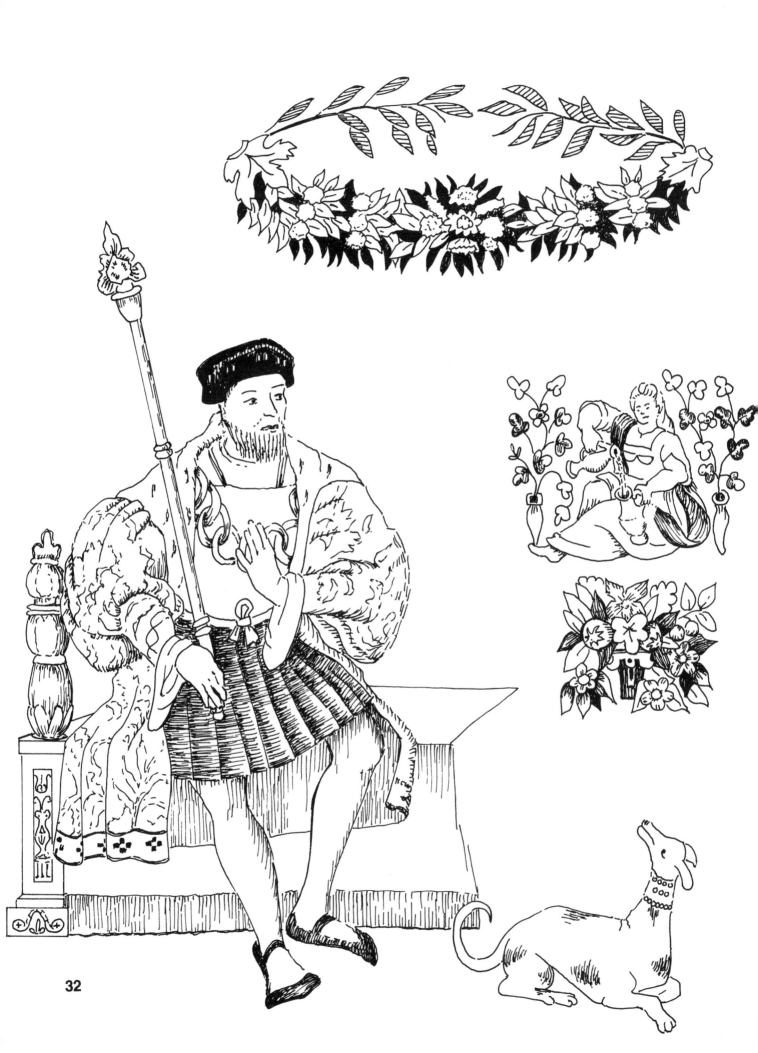

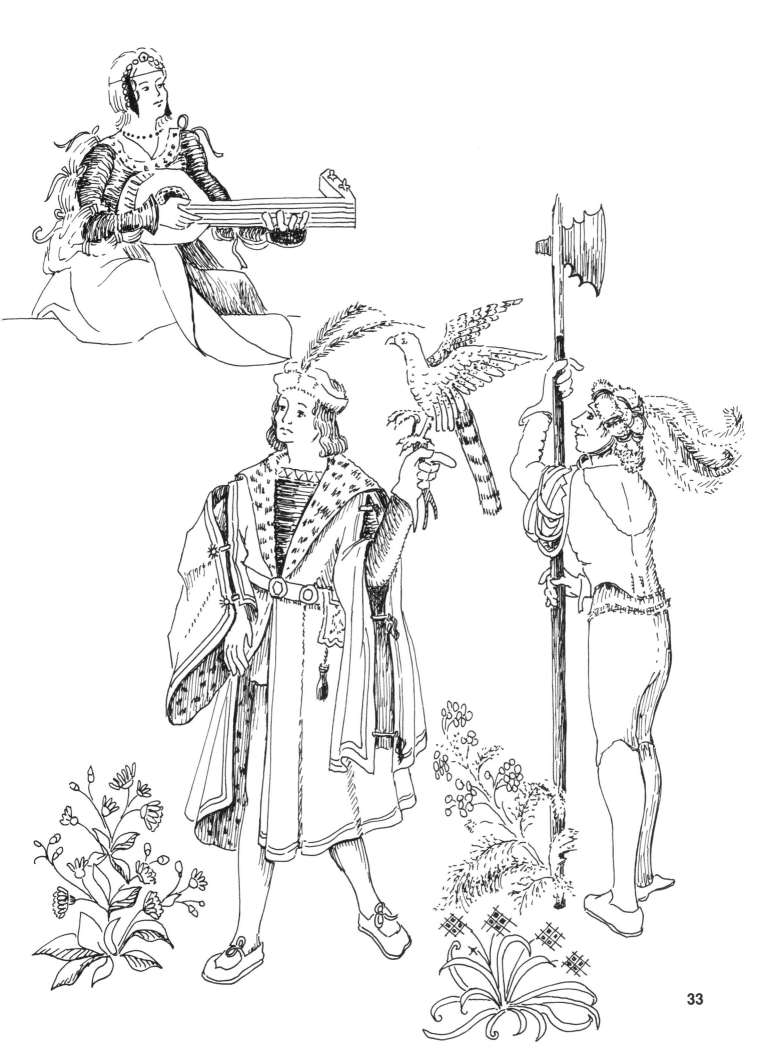

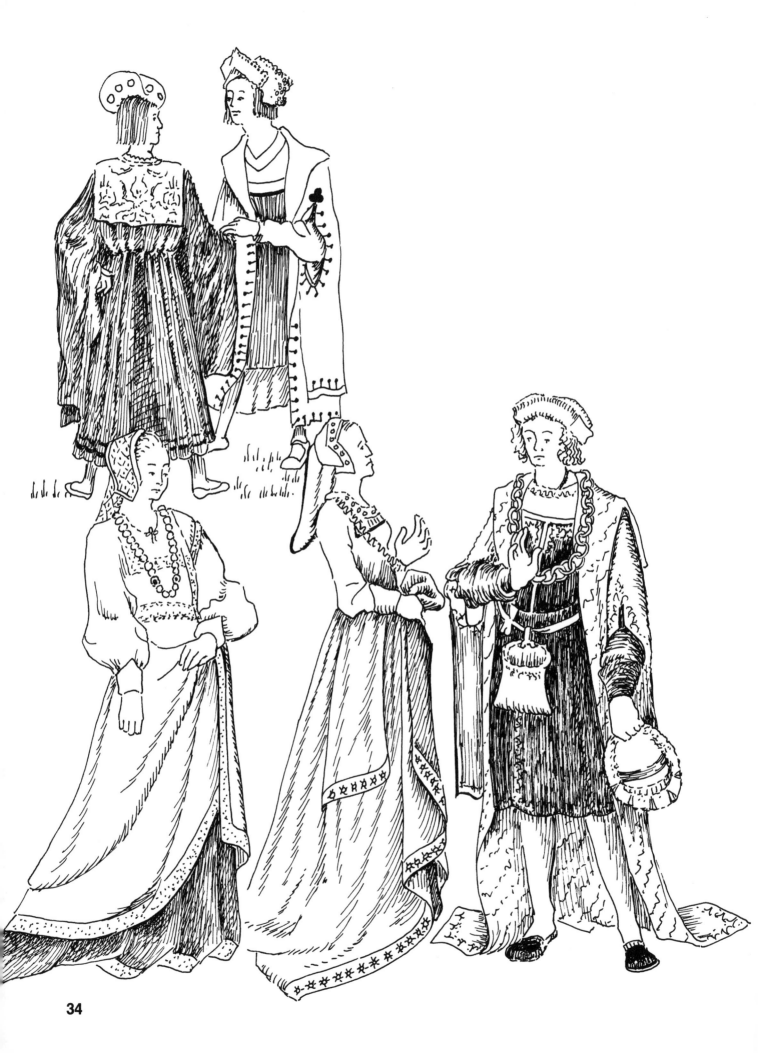

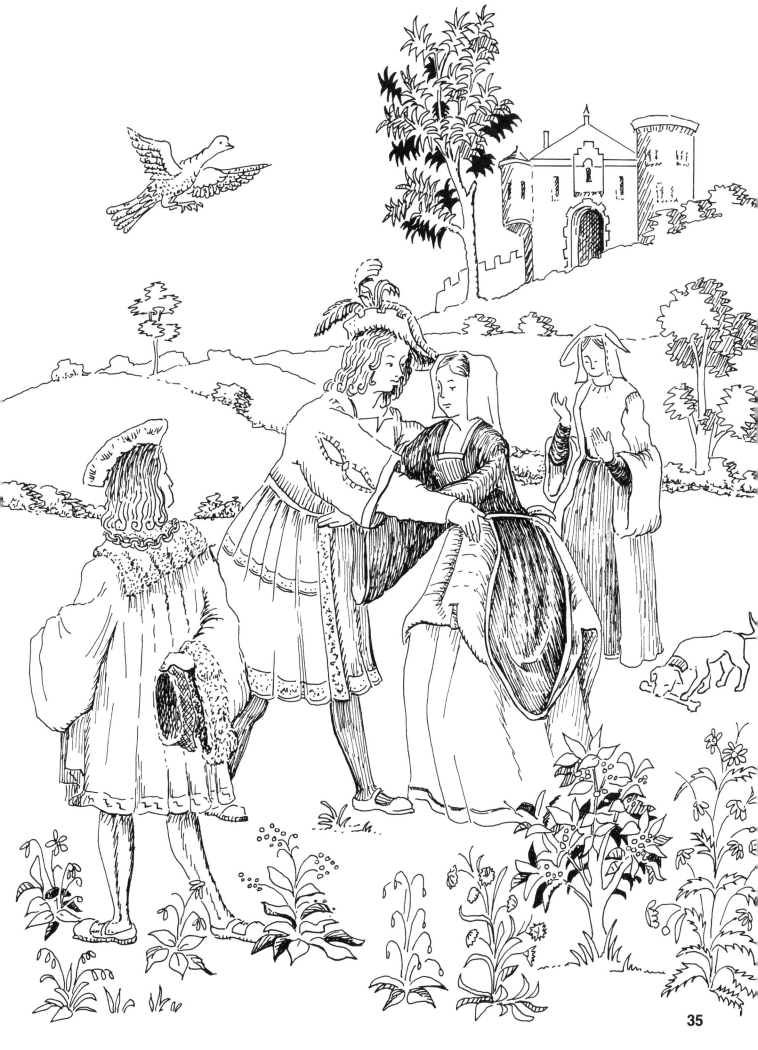

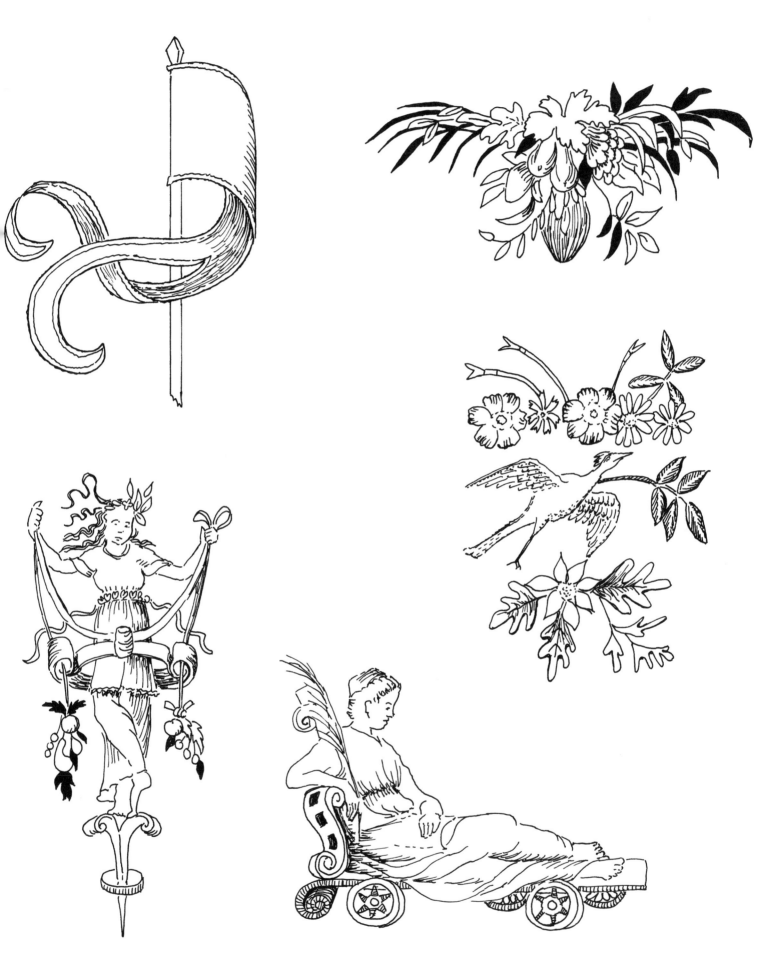

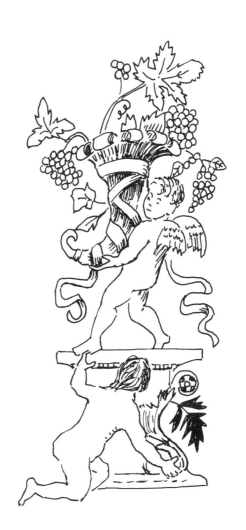

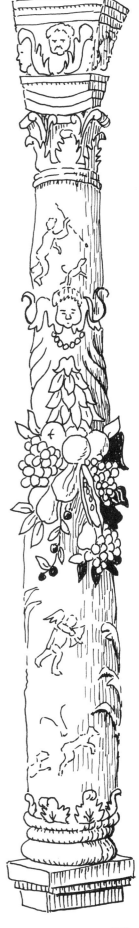

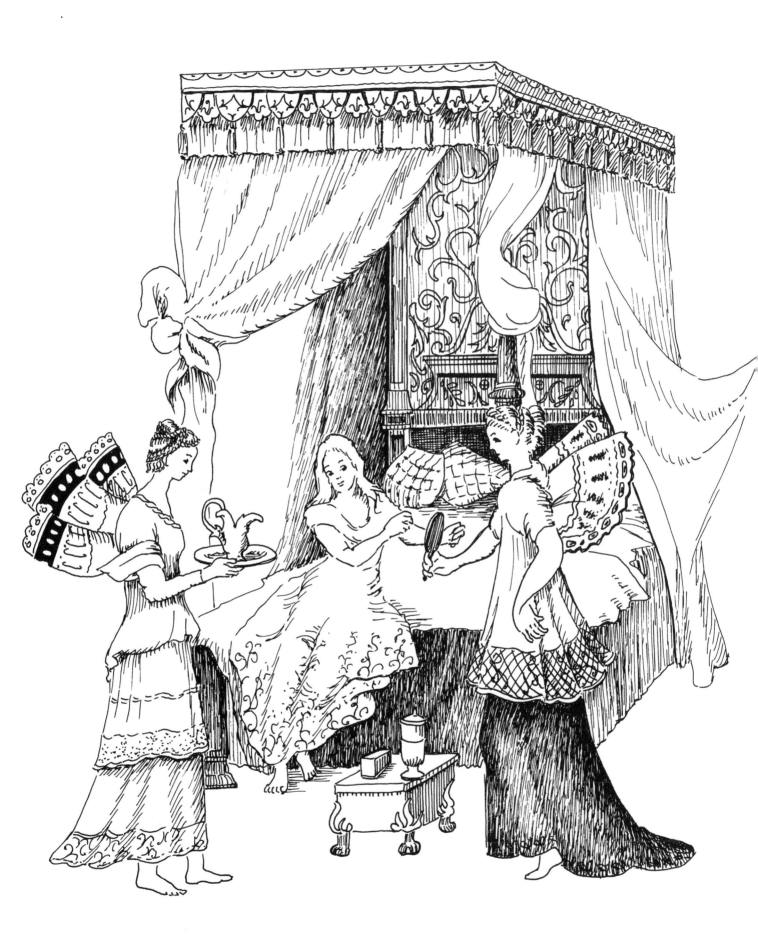

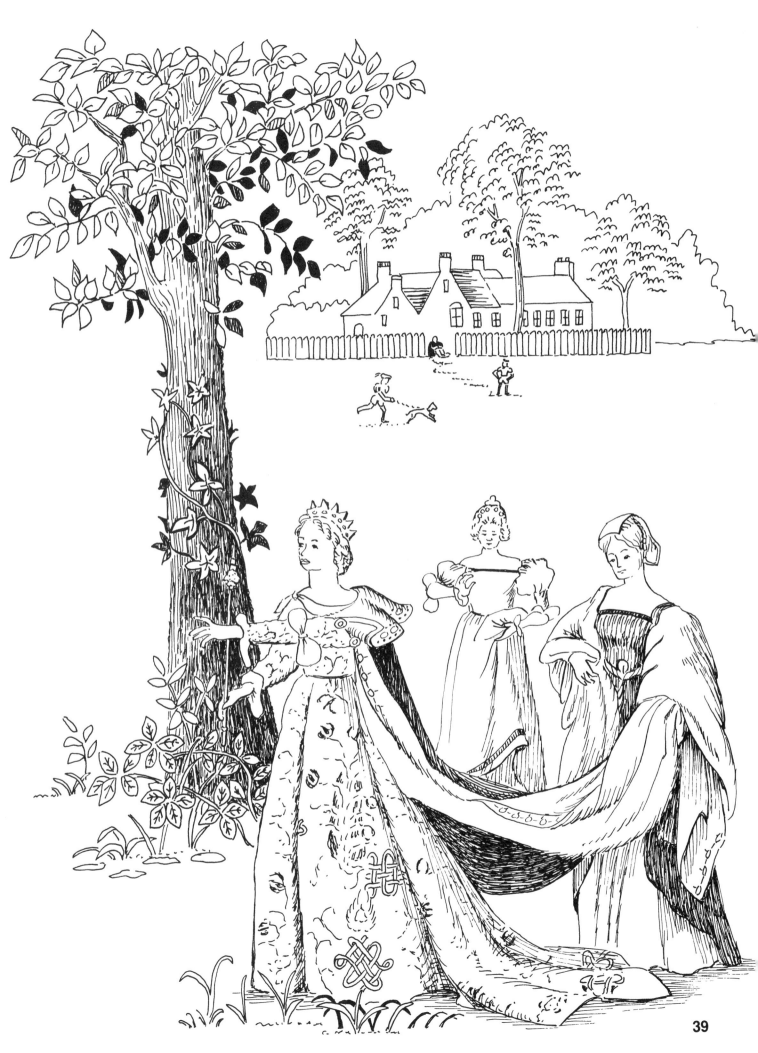

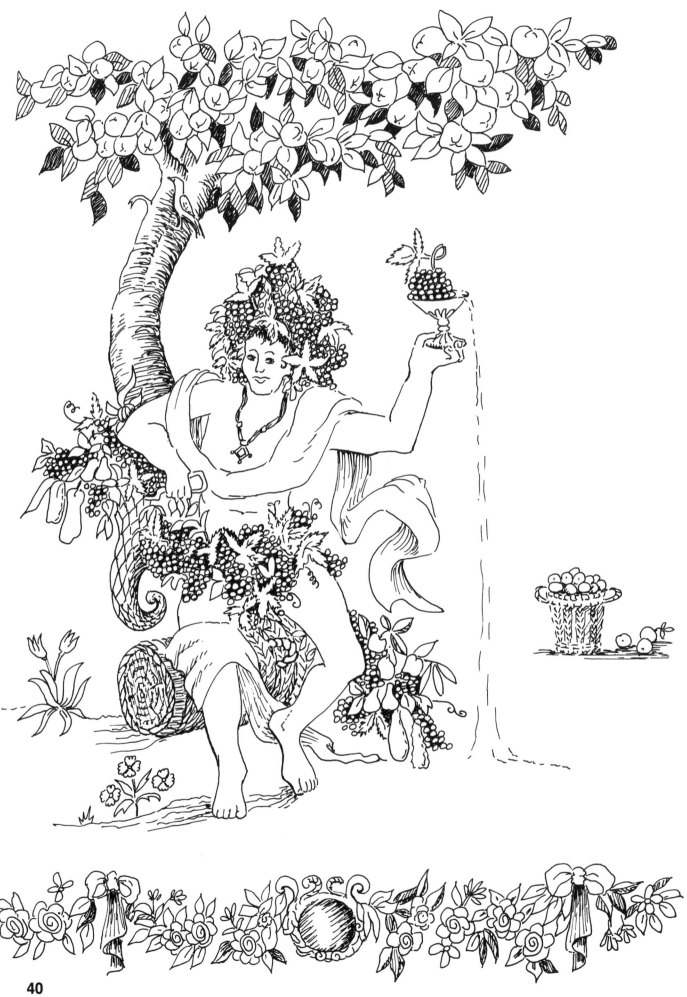

Designed by Barbara Holdridge
Composed in Times Roman by Brown Composition,
 Baltimore, Maryland
Cover color separations by GraphTec, Baltimore,
 Maryland
Printed on 75-pound Williamsburg Offset and bound by
 Hagerstown Bookbinding and Printing Company, Inc.,
 Hagerstown, Maryland